A Norman Rockwell
Christmas

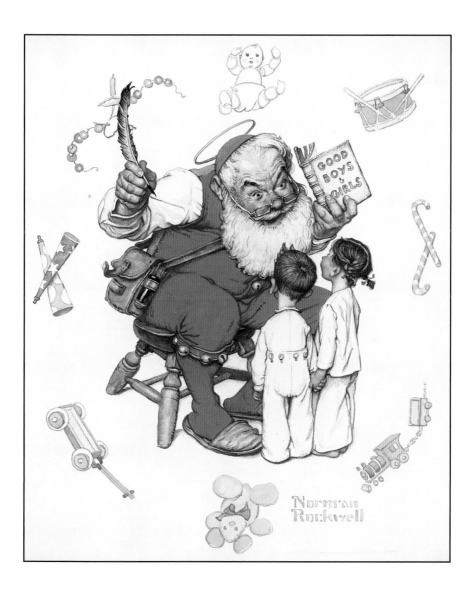

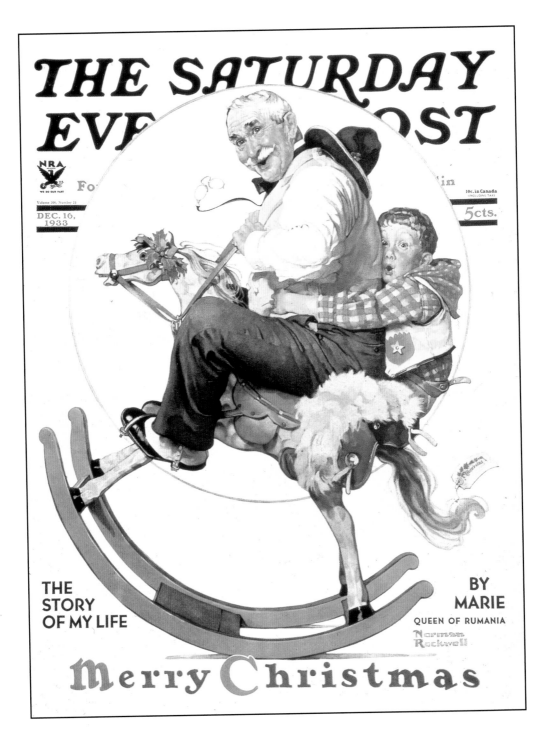

A Norman Rockwell
Christmas

BARNES
&NOBLE
BOOKS
NEW YORK

A BARNES & NOBLE BOOK

©2000 by Michael Friedman Publishing Group, Inc.

ISBN 0-7607-4629-X

Editor: Ann Kirby-Payne
Art Director: Jeff Batzli
Photography Editor: Kathleen Wolfe
Production Manager: Christina Grillo

Color separations by Fine Arts Repro House Co., Ltd.
Printed in Great Britain by Butler & Tanner Ltd., Frome & London

1 3 5 7 9 10 8 6 4 2

 A Merry Rockwell Christmas to All
Margaret T. Rockwell

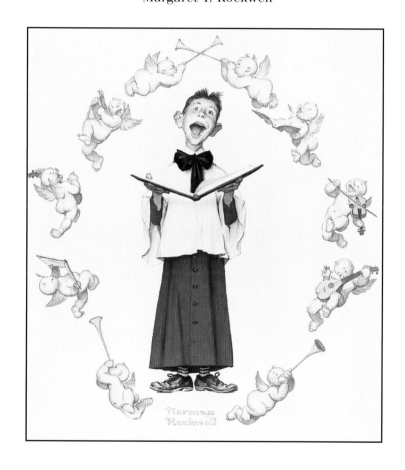

❧ Introduction ❧

Norman Rockwell liked to say that his great-uncle Gil always had the spirit of Christmas about him. An eccentric old gentleman who'd had a successful career as an inventor, Uncle Gil was—according to Rockwell—always giggling and full of good will. He had a charming tendency to mix up holidays, arriving at the Rockwell home at Christmastime with a supply of Fourth of July firecrackers, or bringing Christmas gifts to Easter dinner.

One particular Easter Sunday, Gil arrived at what he thought was the Rockwell home with his usual armload of ill-timed Christmas gifts for his grand-nephews, Norman and Jarvis. As was his habit, Gill set about hiding the gifts throughout the house—under the boys' pillows, on the mantelpiece, and behind the doors. But poor Uncle Gil had gone to the wrong house, and when the Rockwells returned home from church, they found their neighbors on their doorstep, wondering why this confused old gentleman was hiding Christmas presents in their house in mid-April. As Uncle Gil stood uncomfortably beside them with his presents all askew, young Norman felt tremendous sympathy for the kind-hearted old man. After all, Uncle Gil was just attempting to spread some Christmas joy, even if he was a bit confused about the time of year.

Rockwell's appreciation for his great-uncle Gil's holiday spirit shines in a painting he did for the cover of the *Saturday Evening Post* in 1936. Depicting Gil as a jovial old man who lets a young child search through his enormous pockets for a hidden puppy, Rockwell captures the merry charm of a man for whom the joy of Christmas was not limited to a particular season. It is a sense of wonder and merriment that reverberates through virtually every one of Rockwell's holiday paintings. The joy is found in the twinkling eyes of the old and the young when generations are reunited, and when children experience the magic of the season for the first time.

Little Boy Reaching into Grandfather's Overcoat

First published on the cover of *The Saturday Evening Post*, January 25, 1936

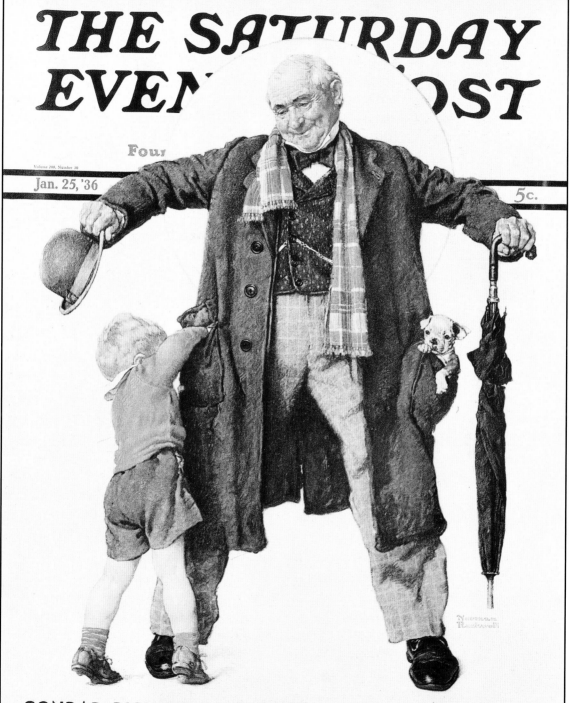

THE SATURDAY EVENING POST

Four

Volume 208, Number 30

Jan. 25, '36

5c.

CONRAD RICHTER · **ROBERT MOSES** · **J. P. McEVOY**

Gil's year-round Christmas magic and unique ability to reach through the generations and touch the lives of his young nephews left a lasting impression on Norman. The artist began his career creating illustrations for children's magazines, and depictions of old men interacting with children quickly became a Rockwell specialty. Playful moments between old and young often turned up as subjects for Rockwell's holiday paintings: a 1921 *Literary Digest* cover, for example, portrays a grandfather telling the Christmas story to his grandchildren (page 43), and on *The Saturday Evening Post* Christmas cover from 1933, a grandfather takes the reins of his grandchild's rocking horse, taking his young grandson for a wild ride (page 37).

Family was not the only source of inspiration for Rockwell. The artist often likened his jovial and eccentric great-uncle to the fictional Mr. Dick, a character from Charles Dickens' classic novel *David Copperfield*. The very comparison is rife with meaning, as Rockwell associated the work of Dickens with boyhood memories of his own father reading the writer's novels aloud at the dining room table while the young artist sketched. The elaborate Victorian dress and old-world charm of Dickens' characters provided fantastic inspiration for Rockwell's paintbrush, and many of the artist's holiday illustrations depicted scenes from those old and enduring

novels. The gregarious Mr. Fezziwig, sweet Tiny Tim, and stoic Bob Cratchet all turned up in Rockwell paintings, as did countless unnamed Victorian revelers, carolers, and coachmen, all decked out in top hats or bonnets decorated with sprigs of holly, toting wreaths, trees, gifts, and holiday cheer. Indeed, one Rockwell illustration—featured on a 1937 *Reader's Digest* subscription card—depicted Dickens' characters emerging from the pages of *A Christmas Carol,* under which the artist added the inscription, "A Merry Christmas to Everybody. A Happy New Year to All the World," and signed it "Charles Dickens."

Many of Norman Rockwell's most enduring Christmas images depict scenes grounded in reality, perfectly in tune with the time in which they were painted. Rockwell's Santa Claus was both a mysterious spirit and a more familiar, grandfatherly figure, an earthbound personification of the spirit of Christmas. Over the years Rockwell presented Santa Claus in his traditional red suit, with a big belly and a twinkle in his eye as he checked lists, looked after his correspondence, and prepared for the long voyage on Christmas Eve. Yet Rockwell's Santa always remained inarguably human, as when, on a *Post* cover from 1922, he fell asleep on the job, leaving the elves to finish up the toy on which he'd been working.

An even more human Santa, or at least a sneak peek at his helpers, was also a Rockwell staple. Good old Saint Nick was an old man with a fake beard after all, as Rockwell demonstrated in his first *Saturday Evening Post* Christmas cover (in 1916), in which an old gentleman tries on a white beard and red hat in a novelty shop. Just after Christmas in both 1940 and 1956, the *Post* printed Rockwell paintings that unveiled Santa's secret humanity. In the first (page 77), a youngster returning home from a shopping expedition spies an exhausted department store Santa on the same commuter train, his fake white beard and red hat stuffed into his pocket. In the latter (page 76), a boy finds the incriminating evidence—red suit, hat, and long white beard—stored among the mothballs of his father's bottom dresser drawer. Humans make the magic, Rockwell reminded us, placing the spirit of Christmas in our own hands rather than in those of some otherworldly entity. Reminding us of our own ability and responsibility to bring joy seemed to be on Rockwell's agenda, even in the worst of times: such was the message when he painted Santa's warm and familiar face bursting through the frightening wartime headlines on the cover of the *Post* in 1942 (above right).

Perhaps Rockwell's most personal sentiments of the season dealt with thoughts of home. Holiday reunions were a recurrent theme in Rockwell's work, none more poignant

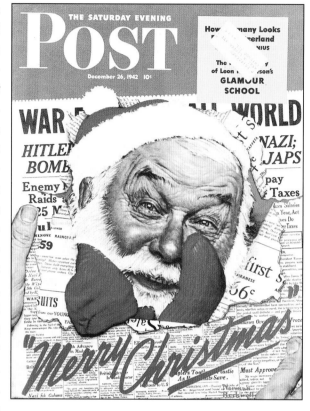

than the artist's rendering of his own eldest son Jarvis' homecoming from boarding school, painted for *The Saturday Evening Post* in 1948 (page 33). The artist placed himself in the scene, with his back to the Christmas tree, looking on as his wife Mary embraces his son while family and friends, among them folk artist Grandma Moses, rejoice. Rockwell's holiday reminiscences included places as well as people, as evidenced by his 1967 painting *Home For Christmas* (pages 34–35). Featuring

Main Street in Stockbridge, Massachusetts, the painting is a loving tribute to the artist's hometown at Christmas time. A magnificent Christmas tree sits in the large window that Rockwell himself had installed when he rented the space above the grocery store for a studio. The Red Lion Inn sits cold and empty, closed for the winter. Beyond it, to the right, is Rockwell's house, windows aglow, and behind the house is the artist's beloved studio.

Home is always a destination at holiday time, and Rockwell joyfully captured the happy bustle of the Christmas rush at Chicago's Union Station in a 1944 painting for *The Saturday Evening Post* (page 32). As in many of Rockwell's frenetic crowd scenes, the artist captures countless personal vignettes in a scene composed of many smaller moments, as people arrive and depart for reunions with friends and family, soldiers and sailors return to embrace their wives, and a Christmas tree is carried across the crowded concourse.

Rockwell also recognized that often his readers were not so lucky to be at home during the holiday season. Many of the artist's Christmastime paintings reminded audiences that home was not merely a place, but a state of mind, a symbol of comfort and warmth that was not defined by bricks and mortar, but by kindness and love. On a 1917 cover for *Leslie's* magazine, a World War I soldier gets a taste of home while sitting in his trench on a European battlefield. The following year, an American soldier shared Christmas in a Belgian home on the cover of *The Literary Digest*. And on a 1941 *Post* cover, the warmth of home emanated from a tiny newsstand covered with snow, where, despite the cold weather and dark headlines, the news vendor is still able to find Christmas peace and warmth in her cozy kiosk (page 31).

Rockwell's paintings have both reflected and defined the American experience for nearly a century, and his Christmas scenes have endured as a chronicle of the American holiday tradition. Year after year, Rockwell's images of wide-eyed children, doting grandparents, Victorian carolers, and festive Santas are infoked to brighten holiday spirits. His paintings fuel our nostalgia for childhood, for home, for times past, and remind us to keep the holiday joyful. This is the Christmas message Rockwell learned from his giggling Uncle Gil. It's a message that transcends the generations. And the paintings reproduced on these pages are about Christmas warmth and good cheer and the merry spirit Norman Rockwell wanted to pass on to us all.

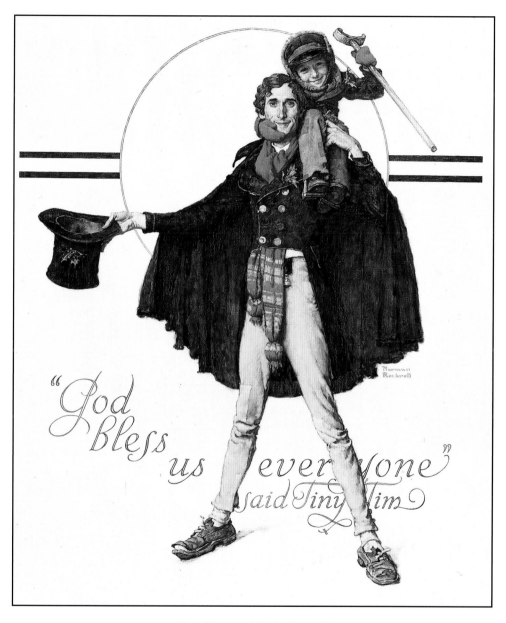

"God Bless us everyone" said Tiny Tim

Tiny Tim and Bob Cratchit

First printed on the cover of *The Saturday Evening Post*, December 15, 1934

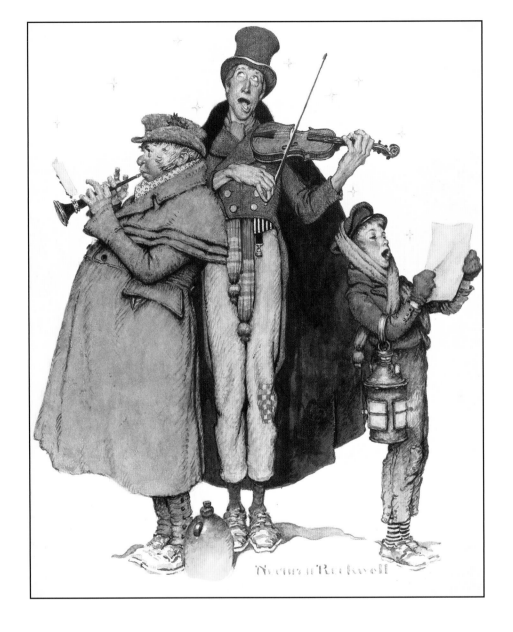

Carolers

Hallmark Christmas card, 1948

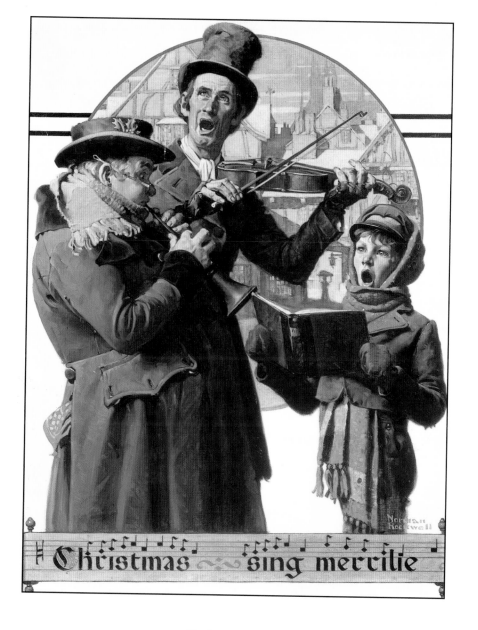

Christmas Trio

First printed on the cover of *The Saturday
Evening Post*, December 8, 1923

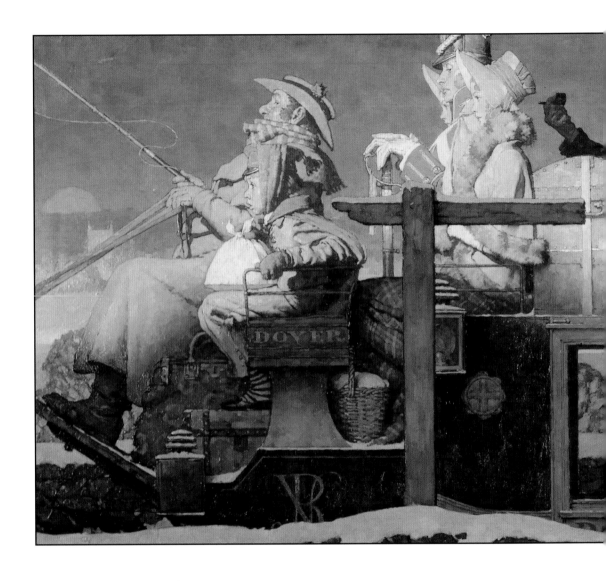

The Christmas Coach

First printed in *The Saturday Evening
Post*, December 28, 1935

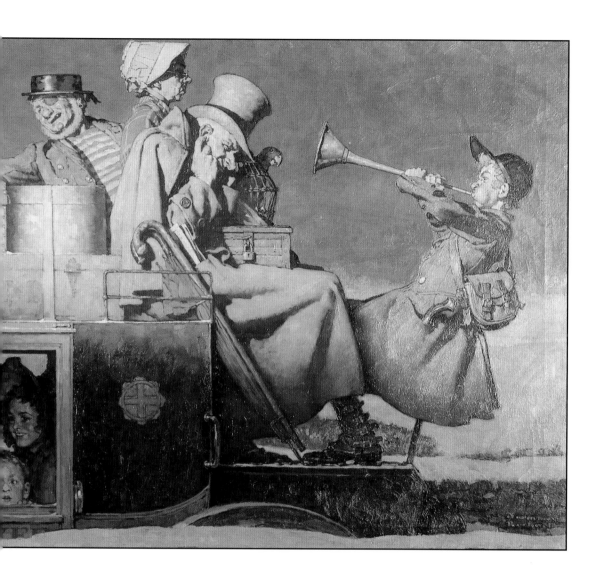

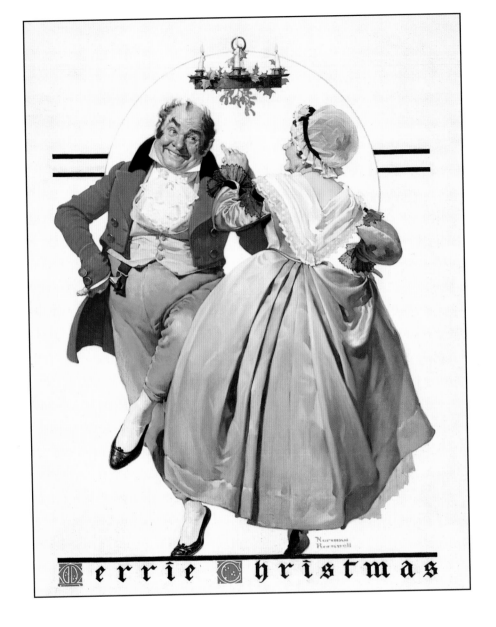

Merrie Christmas: Colonial Couple Under Mistletoe

First printed on the cover of *The Saturday
Evening Post*, December 8, 1928

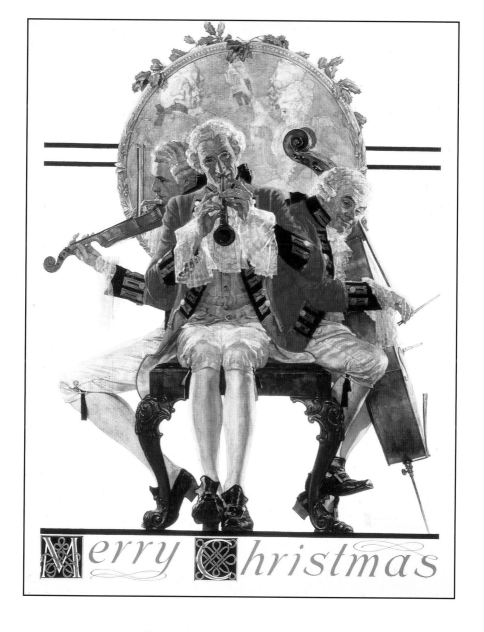

Merry Christmas: Concert Trio

First printed on the cover of *The Saturday
Evening Post*, December 12, 1931

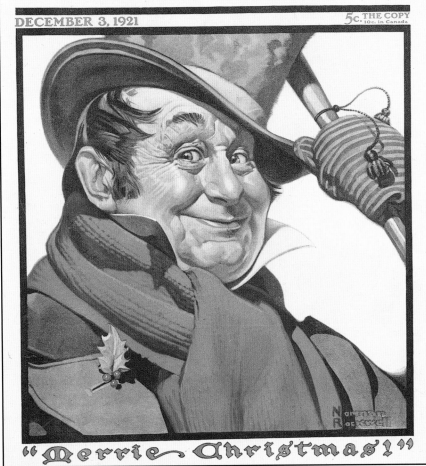

Merrie Christmas!

First printed on the cover of *The Saturday
Evening Post*, December 3, 1921

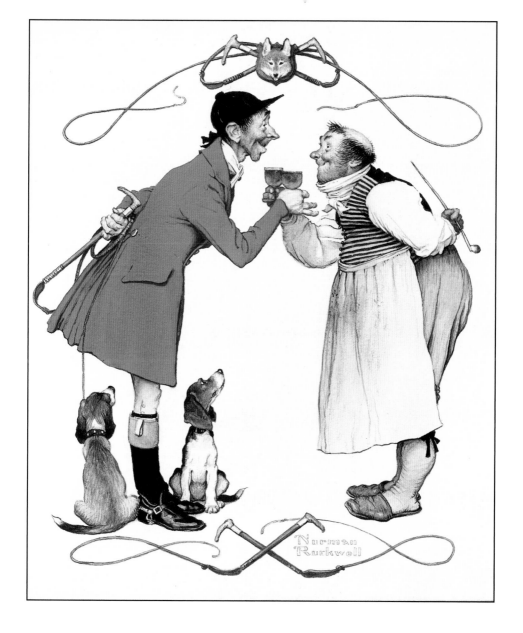

Yuletide Toast

Hallmark Christmas card, 1950

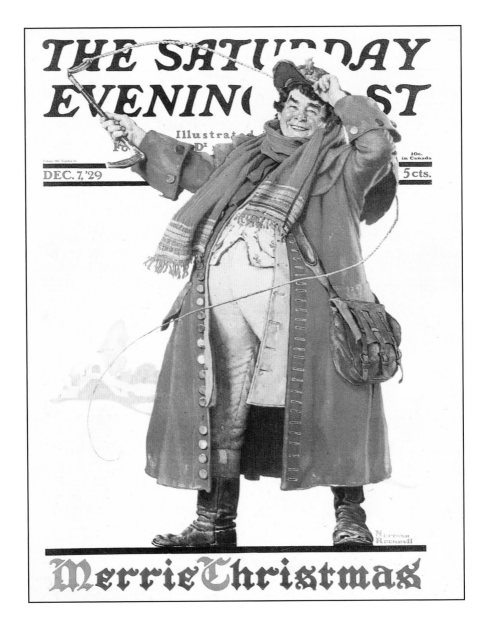

Robust Man with Whip

First printed on the cover of *The Saturday
Evening Post*, December 7, 1929

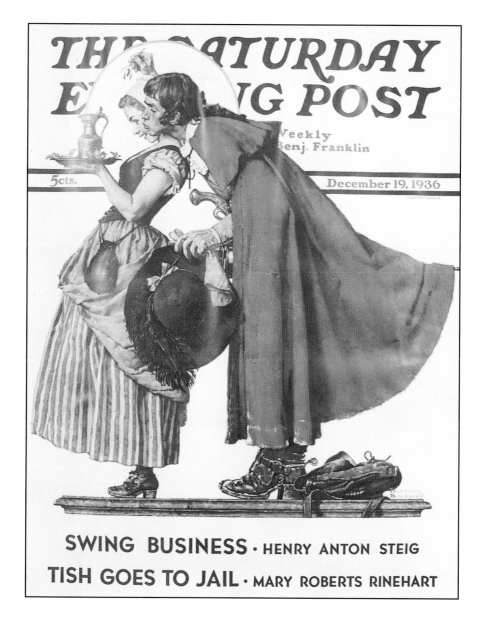

Colonial Couple Under the Mistletoe

First printed on the cover of *The Saturday
Evening Post*, December 19, 1936

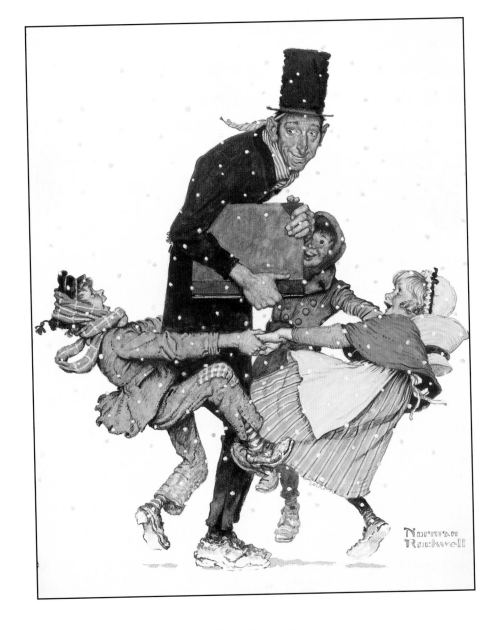

Bob Cratchit

Hallmark Christmas card, 1948

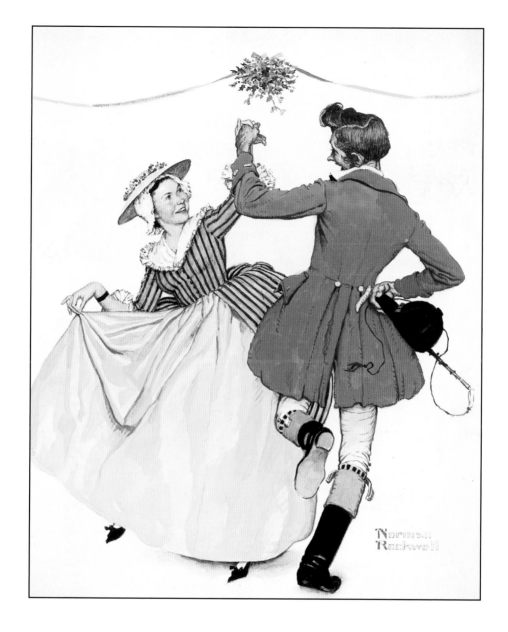

Mistletoe Dance

Hallmark Christmas card, 1948

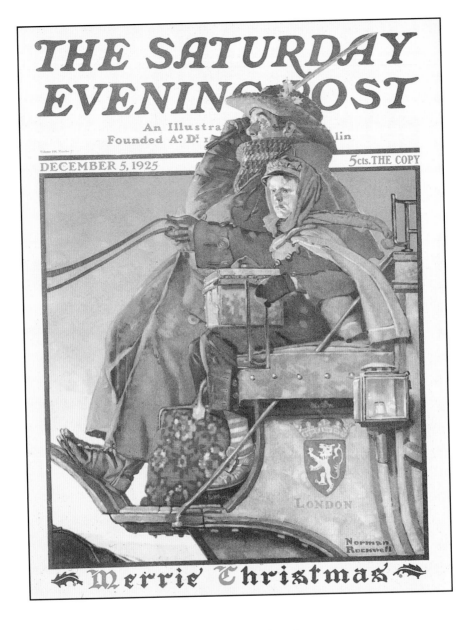

London Stage Coach

First printed on the cover of *The Saturday
Evening Post*, December 5, 1925

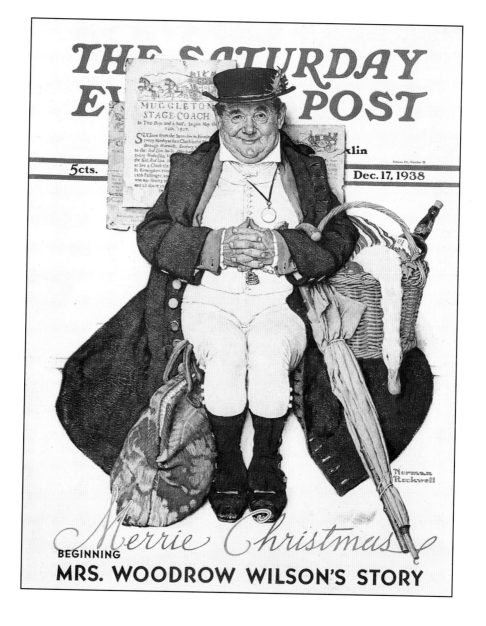

Man With Christmas Goose

First printed on the cover of *The Saturday Evening Post*, December 17, 1938

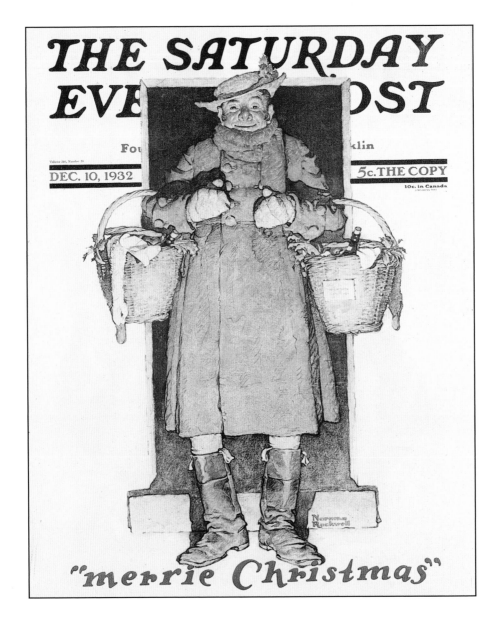

THE SATURDAY
EVE — OST

DEC. 10, 1932

5c. THE COPY

10c. in Canada

"merrie Christmas"

Merrie Christmas: Man With Goose

First printed on the cover of *The Saturday Evening Post*, December 10, 1932

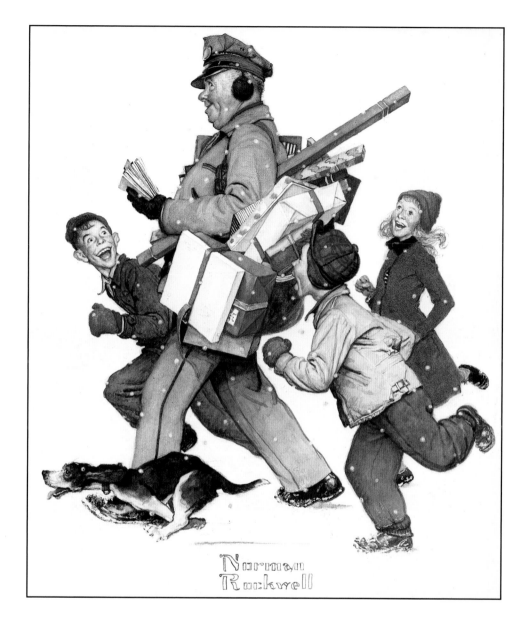

Jolly Postman

Hallmark Christmas card, 1949

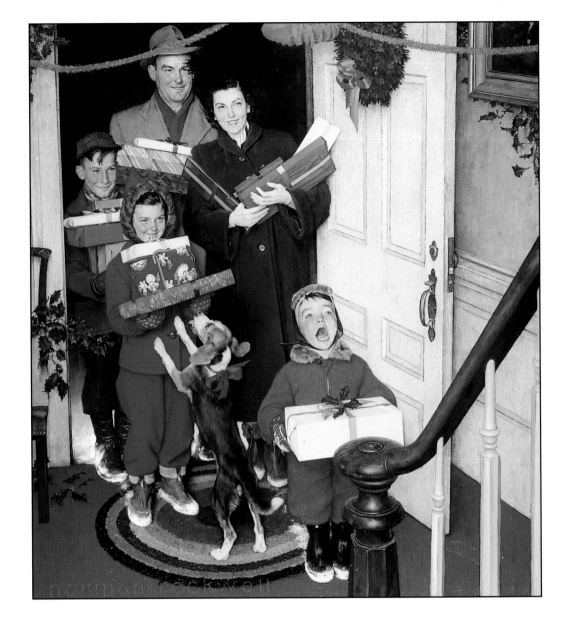

Merry Christmas, Grandma. . . . We came in our New Plymouth!

Plymouth auto advertisement, 1951

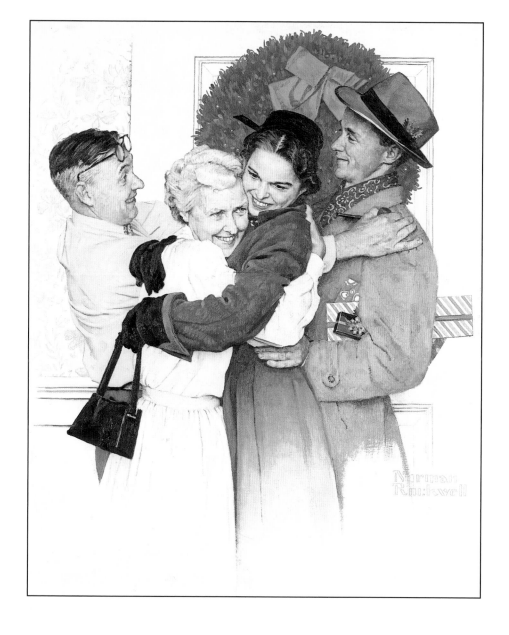

Home For Christmas

Scheaffer Pen advertisement, 1955

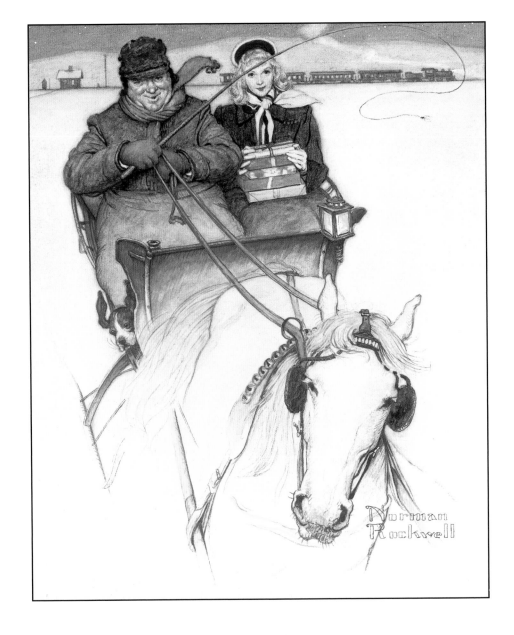

Homecoming

Hallmark Christmas card, 1949

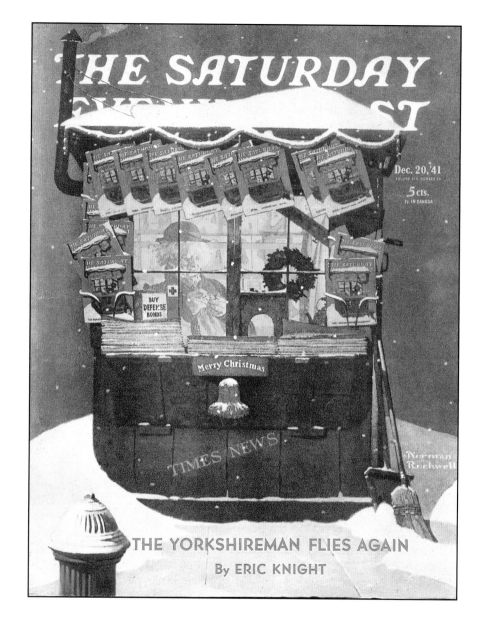

News Kiosk in the Snow

First printed on the cover of *The Saturday
Evening Post*, December 20, 1941

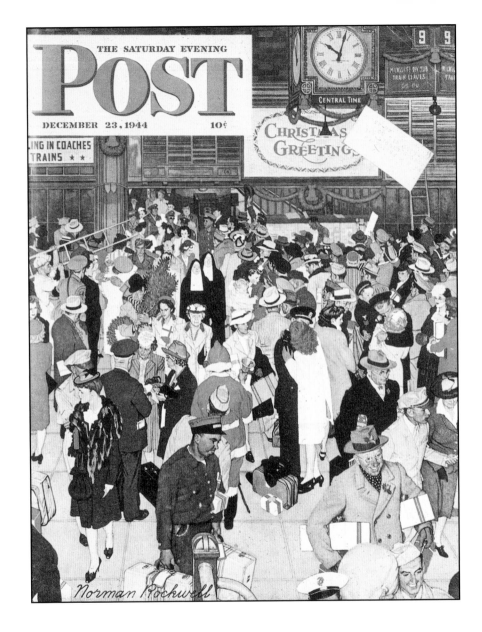

Union Station

First printed on the cover of *The Saturday*
Evening Post, December 23, 1944

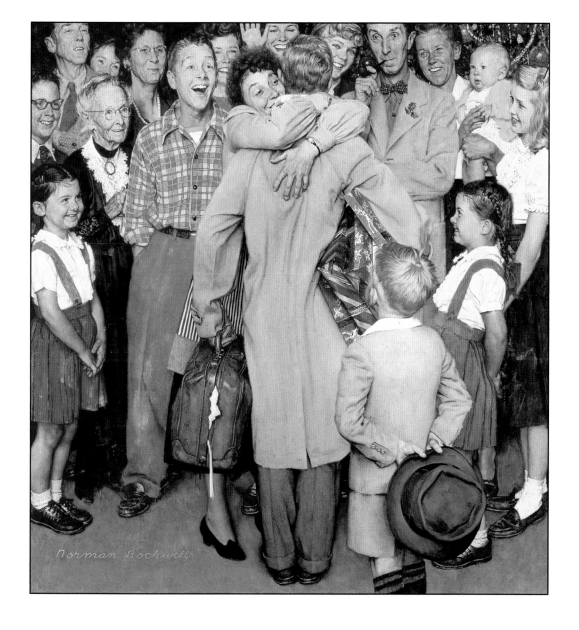

Christmas Homecoming

First printed on the cover of *The Saturday Evening Post*, December 25, 1948

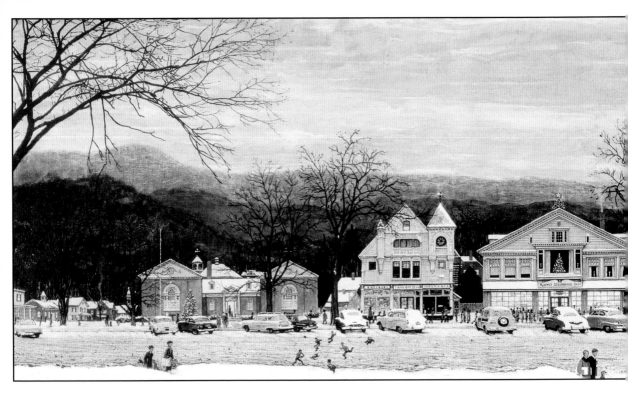

Home For Christmas (Main Street, Stockbridge)

First printed in *McCall's*, December 1967

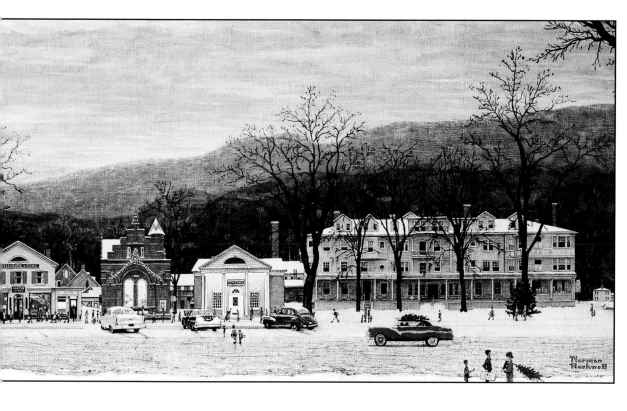

Detail, *Home For Christmas*

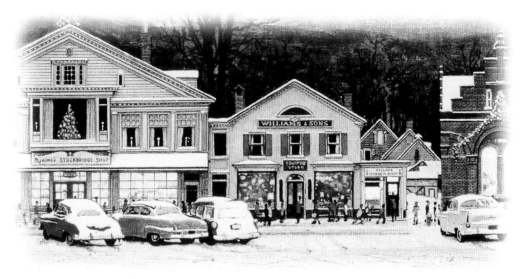

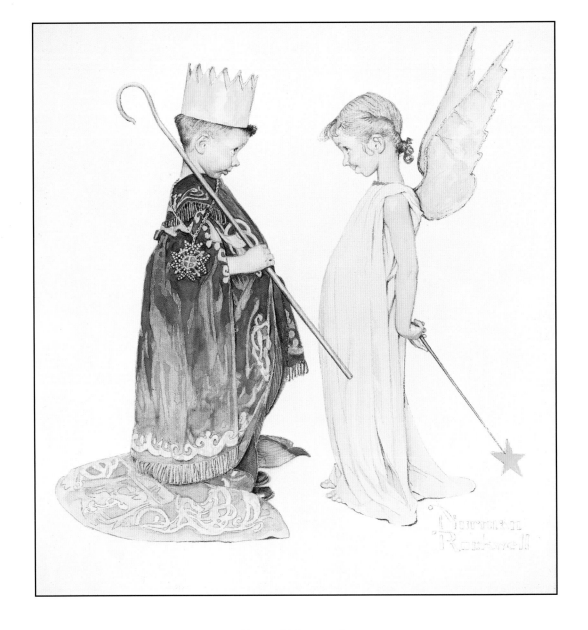

Dress Rehearsal

Hallmark Christmas card, c. 1950s

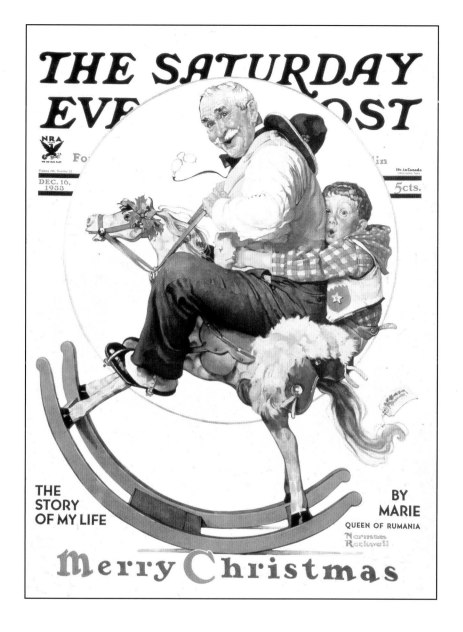

Grandfather and Boy on Rocking Horse

First printed on the cover of *The Saturday Evening Post*, December 16, 1933

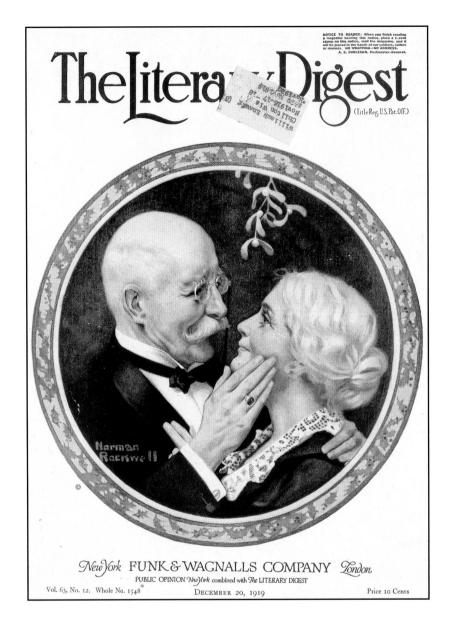

The Literary Digest

(Title Reg. U.S. Pat. Off.)

New York FUNK & WAGNALLS COMPANY *London*

PUBLIC OPINION *New York* combined with *The* LITERARY DIGEST

Vol. 63, No. 12. Whole No. 1548 DECEMBER 20, 1919 Price 10 Cents

Under the Mistletoe

First printed on the cover of *The Literary Digest*, December 20, 1919

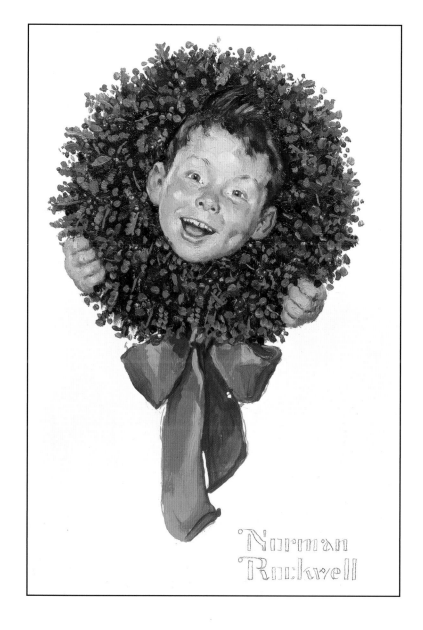

Norman Rockwell

Boy With Head in Wreath

Hallmark study, c. 1950s

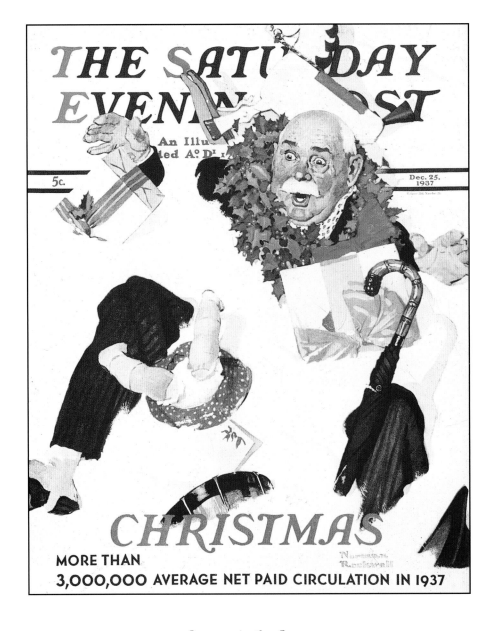

Gramps in the Snow

First printed on the cover of *The Saturday
Evening Post*, December 25, 1937

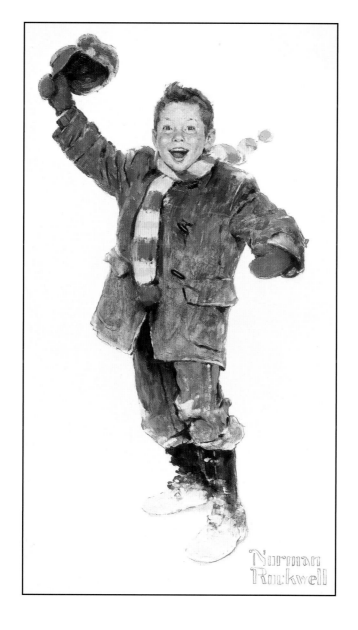

Boy Tossing Cap

Hallmark Christmas card, 1957

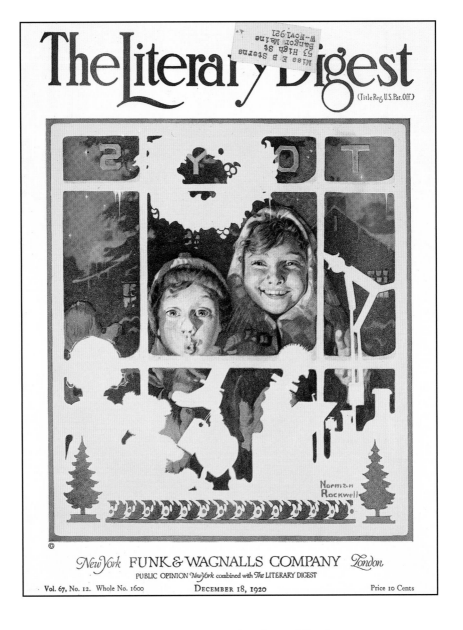

The Literary Digest
(Title Reg. U.S. Pat. Off.)

New York FUNK & WAGNALLS COMPANY *London*

PUBLIC OPINION *New York* combined with *The* LITERARY DIGEST

Vol. 67, No. 12. Whole No. 1600 DECEMBER 18, 1920 Price 10 Cents

Children Looking in Toy Store Window

First printed on the cover of *The
Literary Digest*, December 18, 1920

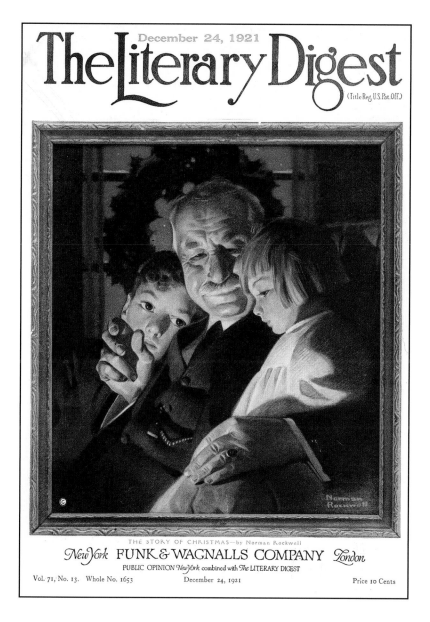

December 24, 1921

The Literary Digest

(Title Reg. U.S. Pat. Off.)

THE STORY OF CHRISTMAS—by Norman Rockwell

New York FUNK & WAGNALLS COMPANY *London*

PUBLIC OPINION *New York* combined with *The* LITERARY DIGEST

Vol. 71, No. 13. Whole No. 1653 December 24, 1921 Price 10 Cents

The Story of Christmas

First printed on the cover of *The Literary Digest*, December 24, 1921

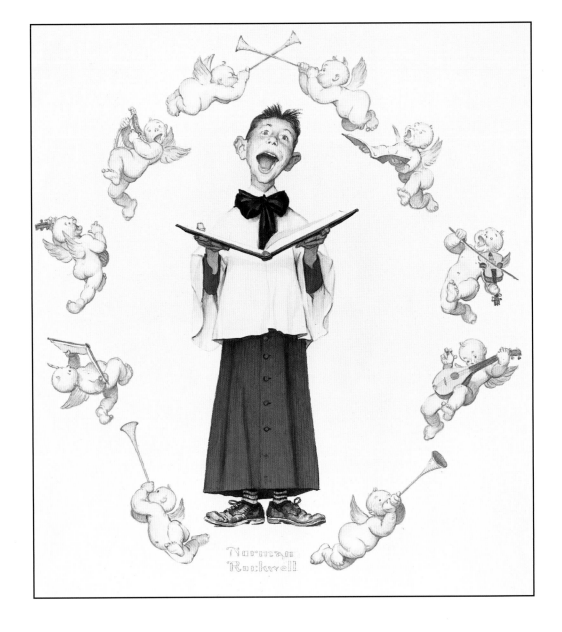

Choir Boy

Hallmark Christmas card, 1950

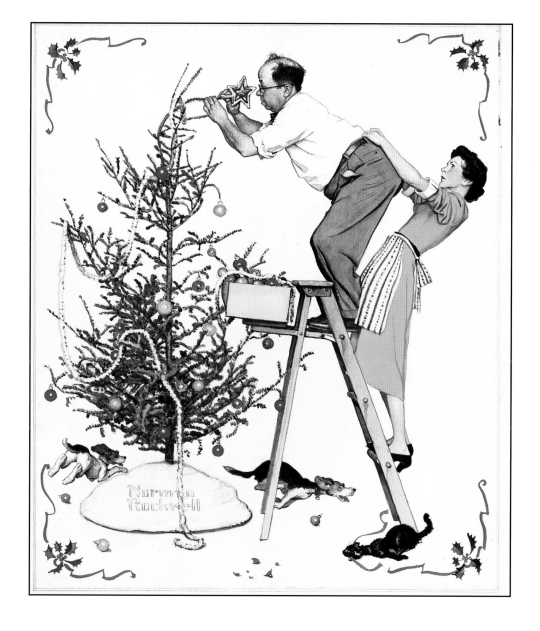

Trimming the Tree

Hallmark Christmas card, 1952

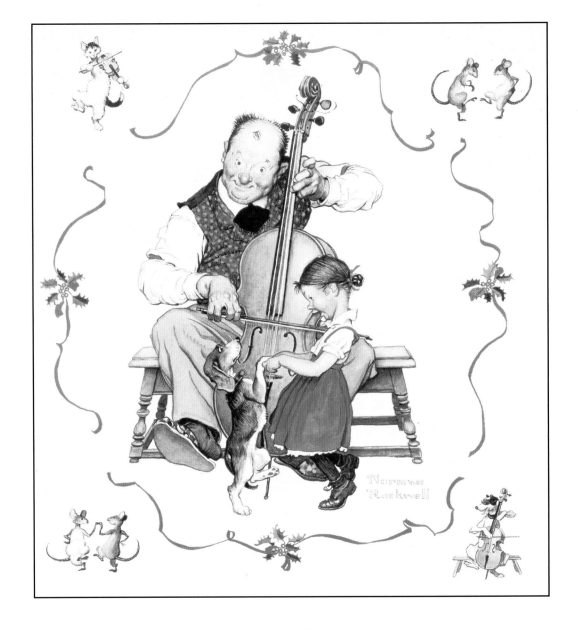

Christmas Dance

Hallmark Christmas card, 1950

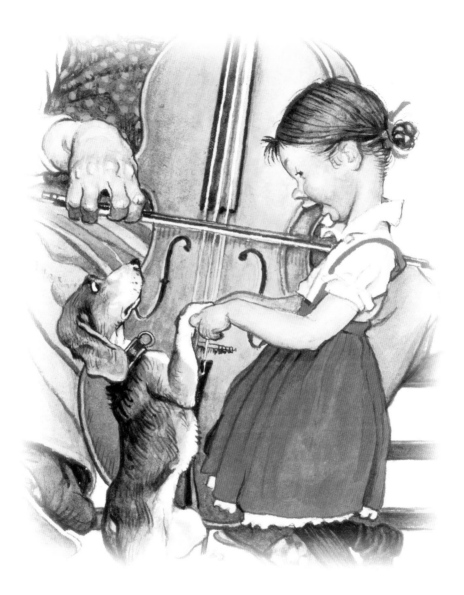

Detail, *Christmas Dance*

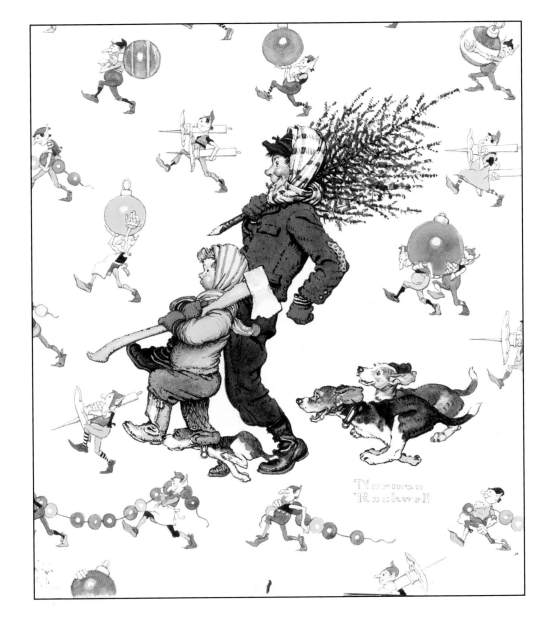

Bringing Home the Tree

Hallmark Christmas card, 1950

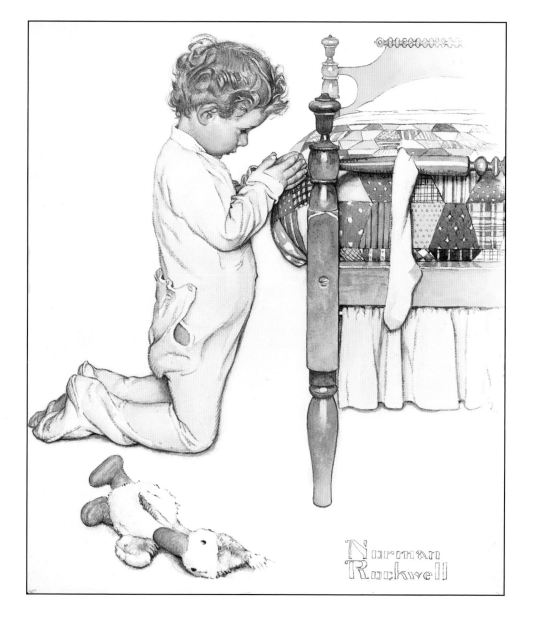

A Christmas Prayer

Hallmark Christmas card, 1949

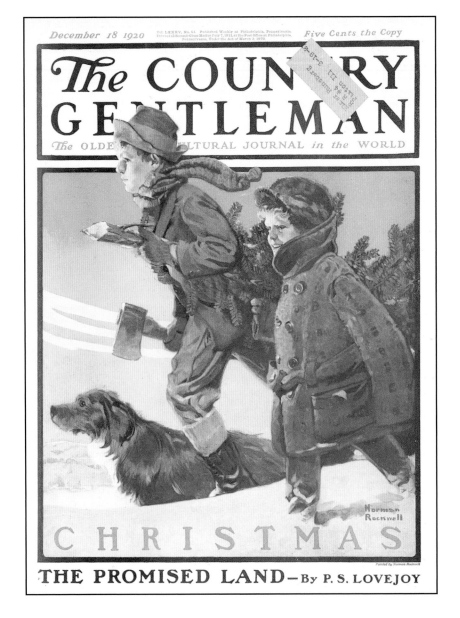

Christmas

First printed on the cover of *The Country
Gentleman*, December 18, 1920

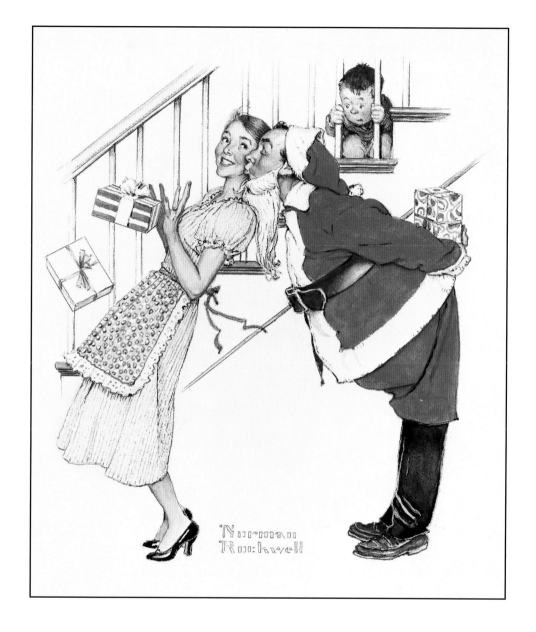

Christmas Surprise

Hallmark Christmas card, 1954

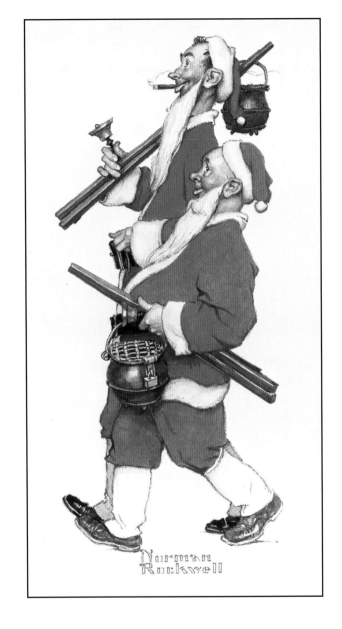

A Good Day

Hallmark Christmas card, c. 1950s

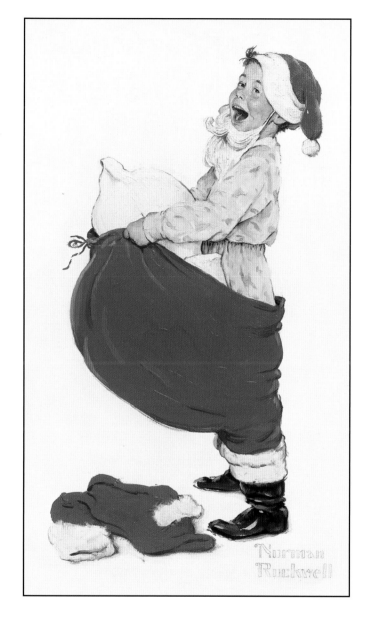

Boy in Santa Suit

Hallmark Christmas card, 1957

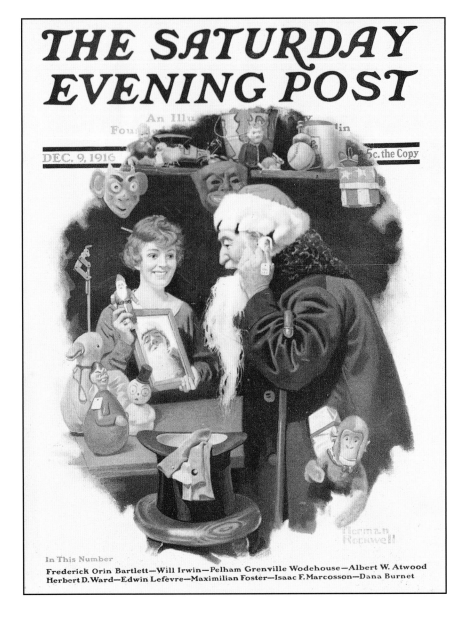

THE SATURDAY
EVENING POST

An Illu...
Fou...

DEC. 9, 1916

5c. the Copy

In This Number
Frederick Orin Bartlett—Will Irwin—Pelham Grenville Wodehouse—Albert W. Atwood
Herbert D. Ward—Edwin Lefèvre—Maximilian Foster—Isaac F. Marcosson—Dana Burnet

Man Playing Santa

First printed on the cover of *The Saturday
Evening Post*, December 9, 1916

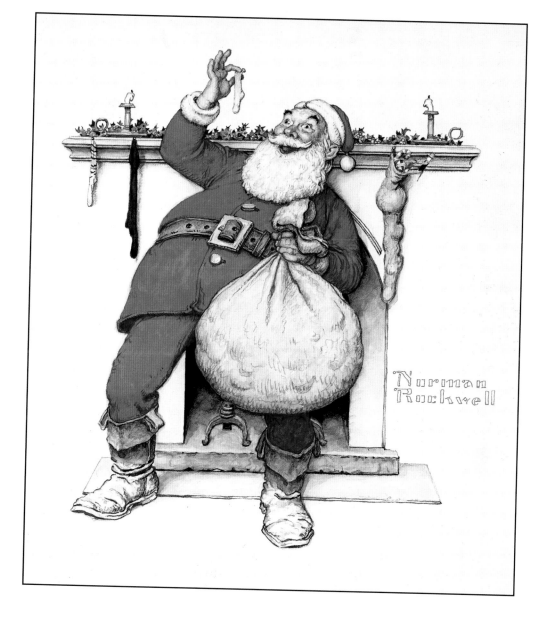

Filling the Stockings

Hallmark Christmas card, 1955

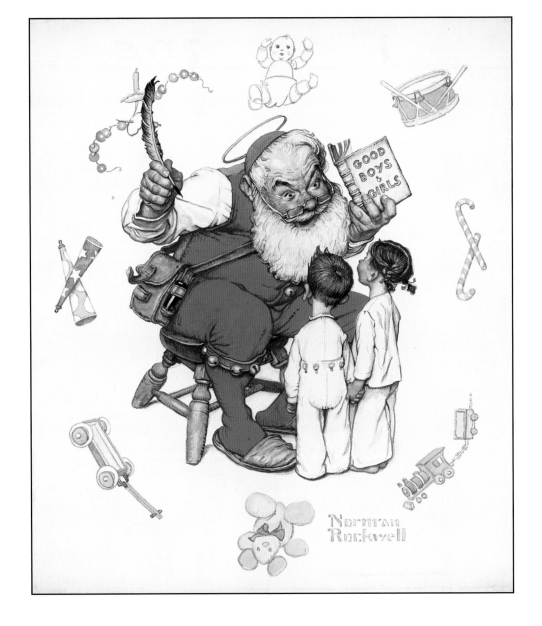

Santa's Visitors

Hallmark Christmas card, 1951

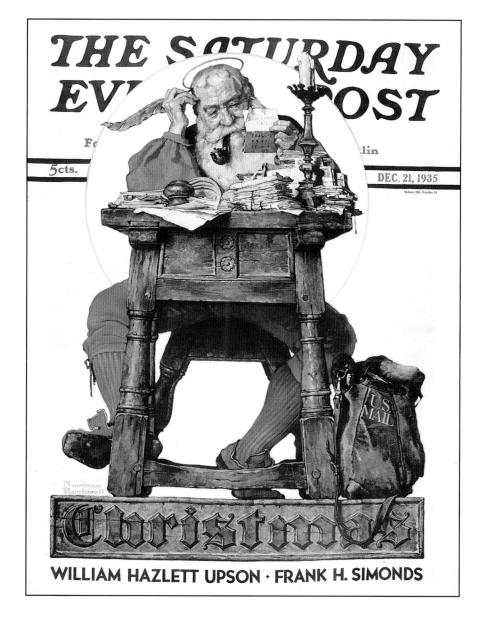

Santa Reading Mail

First printed on the cover of *The Saturday
Evening Post*, December 21, 1935

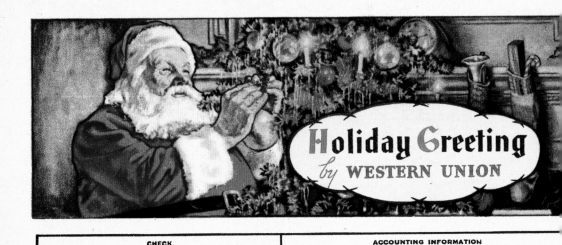

Holiday Greeting
by WESTERN UNION

CHECK			ACCOUNTING INFORMATION	
FULL RATE TELEGRAM		NIGHT LETTER		FULL RATE CABLEGRAM
DAY LETTER		NIGHT MESSAGE		DEFERRED CABLEGRAM

Send the following message, subject to the terms on back hereof, which are hereby agreed to

To_____

*Sender's address
for reference*

THIS MESSAGE WILL BE DELIVERED ON CHRISTMAS DAY (NEW
UNLESS OTHERWISE REQUESTED

701

Created by Norman Rockwell

TIME FILED

CABLE NIGHT LETTER
SHIP RADIOGRAM

_____ 19 _____

AY) *Dee.* *Sender's telephone* 35
number

Holiday Greeting

Western Union telegram, 1935

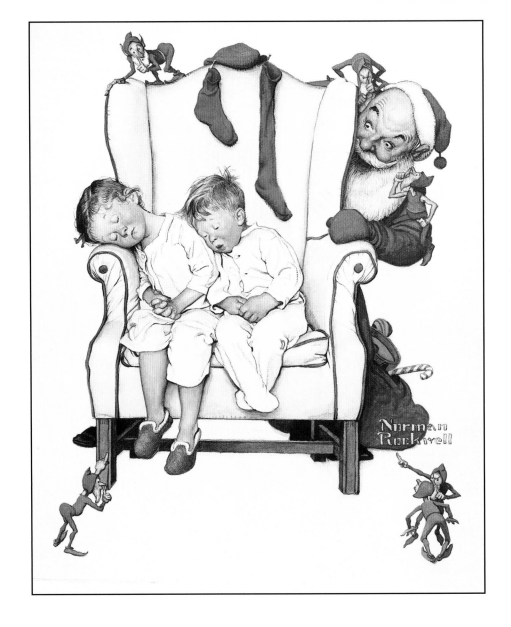

Santa Looking at Two Sleeping Children

Hallmark Christmas card, 1952

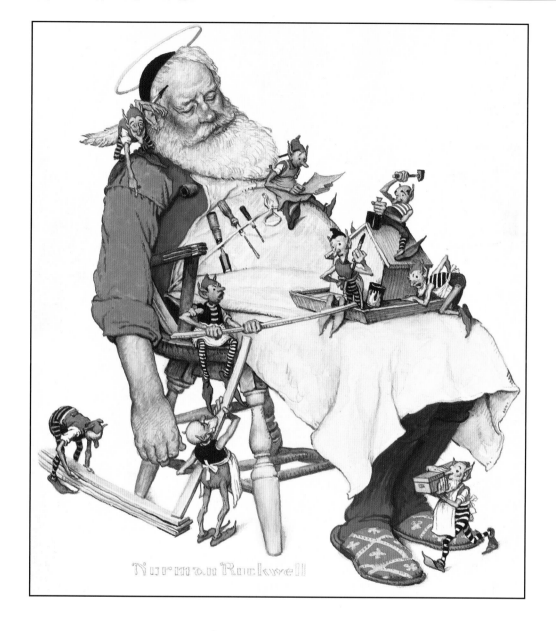

Santa and his Helpers

Hallmark Christmas card, 1948

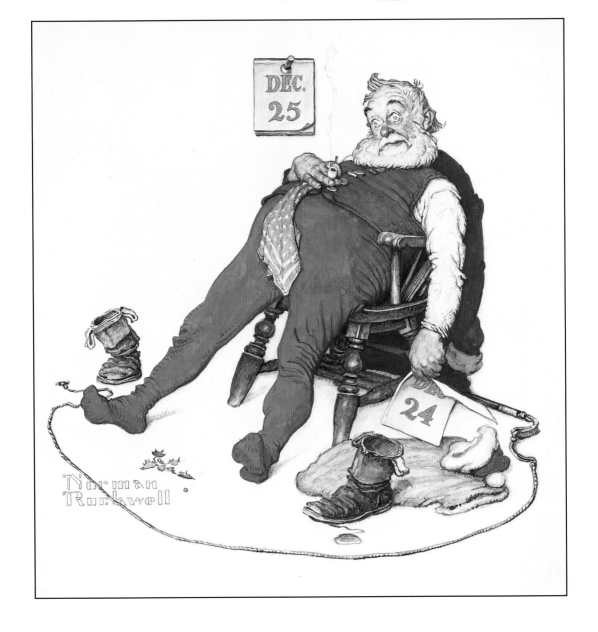

And To All A Good Night

Hallmark Christmas card, 1954

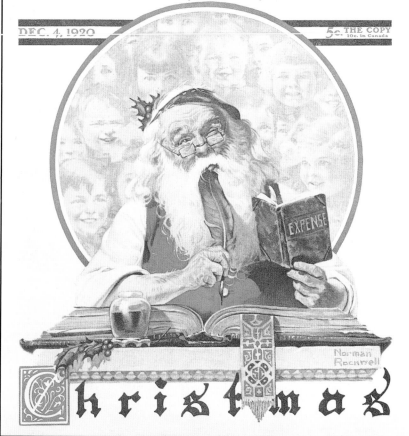

Santa and Expense Book

First printed on the cover of *The Saturday Evening Post*, December 4, 1920

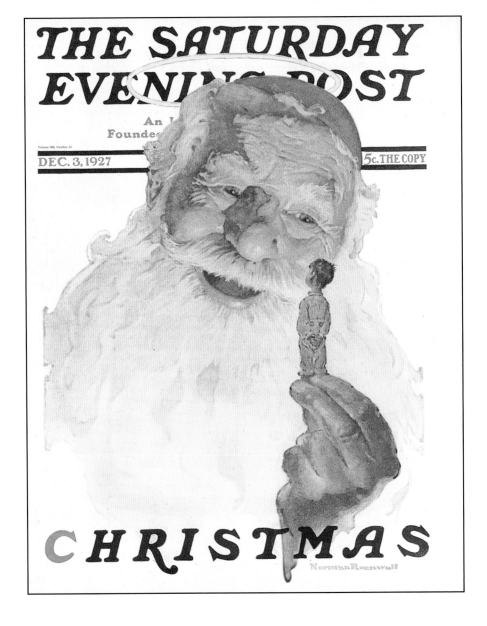

Santa Holding Little Boy

First printed on the cover of *The Saturday
Evening Post*, December 3, 1927

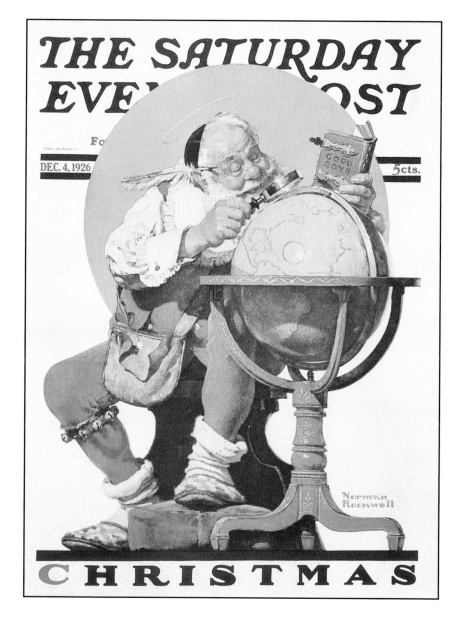

Santa Consulting Globe

First printed on the cover of *The Saturday Evening Post*, December 4, 1926

THE SATURDAY EVENING POST

An Ill⋯ Weekly
Founded A⋯ Benj. Franklin

DEC. 6, 1924 5cts. THE COPY

CHRISTMAS

Santa's Christmas List

First printed on the cover of *The Saturday
Evening Post*, December 6, 1924

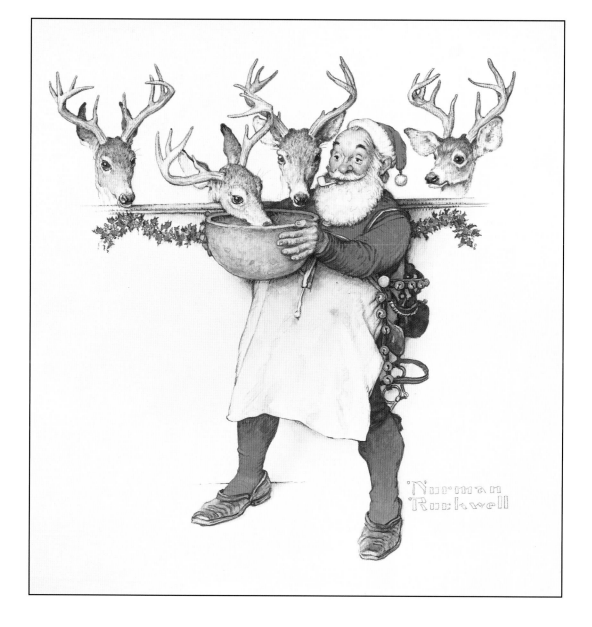

Getting Ready

Hallmark Christmas Card, 1955

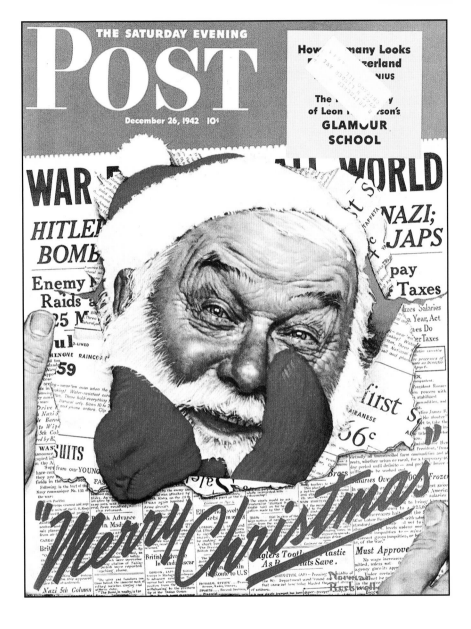

Santa Face in Newspaper

First printed on the cover of *The Saturday
Evening Post*, December 26, 1942

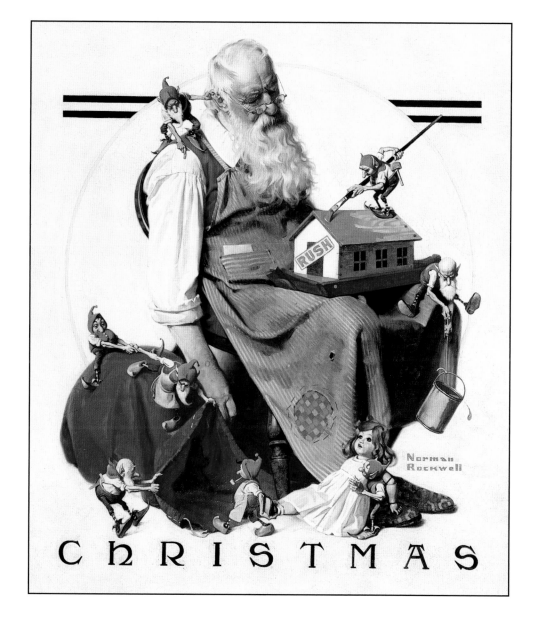

Santa and His Helpers

First printed on the cover of *The Saturday
Evening Post*, December 2, 1922

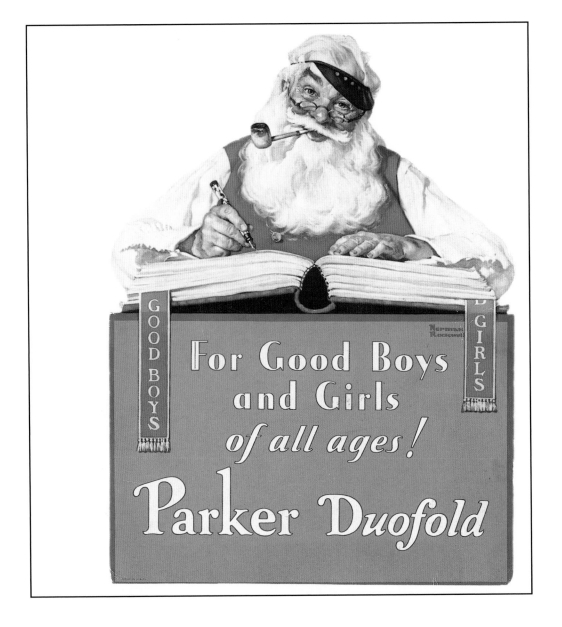

No Christmas Problem Now

Parker Pen advertisement, 1929

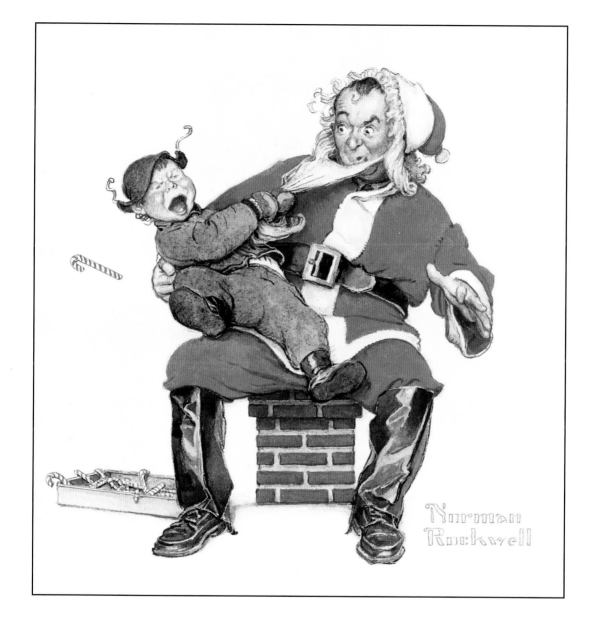

Crying Child Pulling Santa's Beard

Hallmark Christmas card, c. 1950s

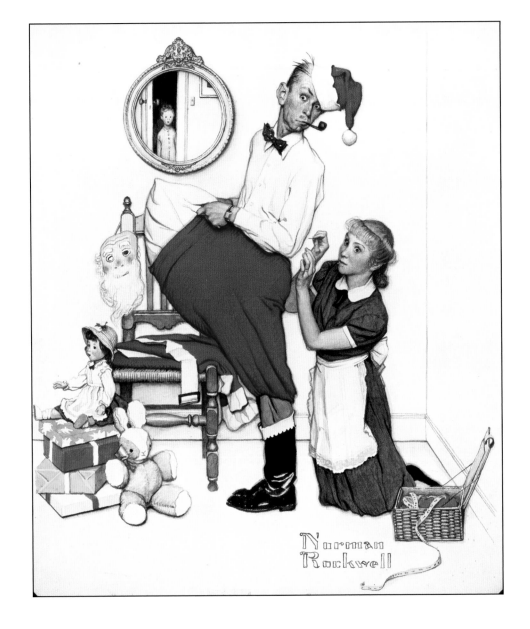

Santa's Surprise

Hallmark Christmas card, 1949

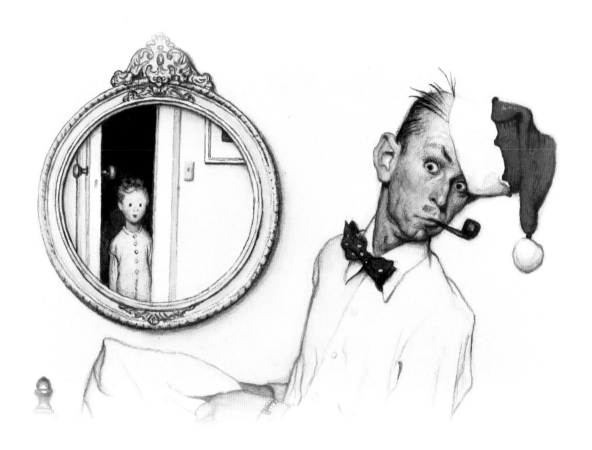

Detail, *Santa's Surprise*

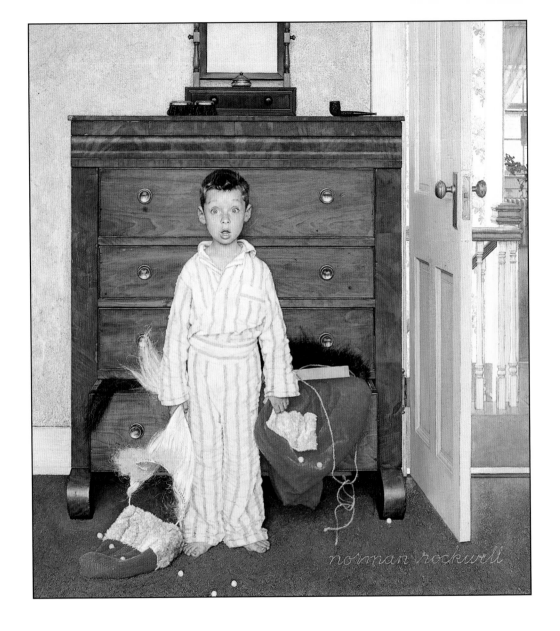

The Discovery

First printed on the cover of *The Saturday
Evening Post*, December 29, 1956

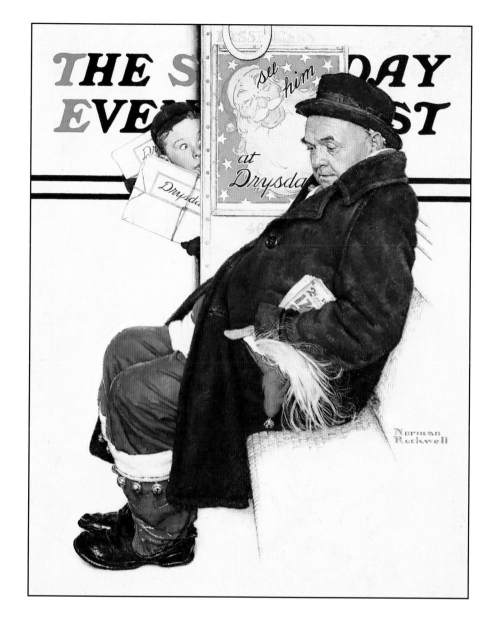

Santa on a Train

First printed on the cover of *The Saturday
Evening Post*, December 28, 1940

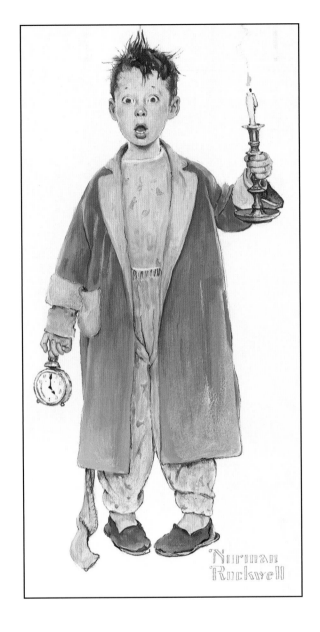

Boy Holding a Candle

Hallmark Christmas card, 1957

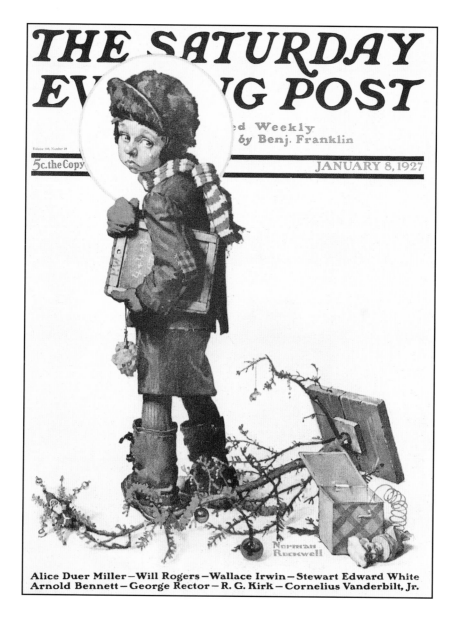

Little Boy Holding Chalk Board

First printed on the cover of *The Saturday
Evening Post*, January 8, 1927